**THREE LEGGED
THEATRE COMPANY**

Three Legged Theatre Company Presents

THE
KINGDOM

Written by Colin Teevan

First performed at Soho Theatre 24 October 2012

**THREE LEGGED
THEATRE COMPANY**

The Kingdom is a Three Legged Theatre Company commission

Three Legged Theatre Company was founded by Lucy Pitman-Wallace and Clare Horrell. The company concentrates on new writing and new translations of European plays, placing the emphasis on clarity of narrative and relationships. As a company they stand for top-quality performance and production values but above all the play is the thing. Three Legged's past work amongst others includes a co-production with York Theatre Royal of *A Special Relationship* by Sara Clifford which toured nationally to venues including the Traverse and Bristol Old Vic.

Three Legged Theatre Company Board Members

Juliet Webster

Charlotte Eilenberg

Larry Jones

Three Legged Theatre Company would like to thank the following people for their support with the development of the production: The Liverpool Everyman, Suzanne Bell, Gemma Bodinetz, The Peggy Ramsay Foundation, Birkbeck College, London Bubble, The Actors Centre, Billy Carter, Kerr Logan, Col Farrell, Tony Rohr, Neil Caple, Mark Arends, Sarah Dickinson, Nina Steiger and Soho Theatre, Claire Birch, English Touring Theatre, Daniel Neville, and Richard Wakely

CAST

Young Man	**Anthony Delaney**
Man	**Owen O'Neill**
Old Man	**Gary Lilburn**

COMPANY

Director	**Lucy Pitman-Wallace**
Designer	**Jessica Curtis**
Lighting Design	**Oliver Fenwick**
Composition & Sound Design	**Paul Dodgson**
Movement Director	**Simon Pittman**
Three Legged Producer	**Clare Horrell**
Executive Producer	**Michael White**
Assistant Producer	**Rosie Clark**
Production Manager	**Ali Beale**
Stage Manager	**Beth Hoare-Barnes**
Assistant Stage Manager	**Caroline Butler**
Casting	**Zoë Waterman**
Casting Consultant	**Kay Magson**
Researcher to the Author	**Aisha Zia**
Graphic Designer	**Michael Windsor-Ungureanu**
Press Agent	**Cliona Roberts** cliona@crpr.co.uk
Marketing Consultant	**Kim Morgan** kim@kimmorgan-pr.com
Photographer	**Robert Day**

CAST

ANTHONY DELANEY – YOUNG MAN

Anthony trained at The Central School of Speech and Drama. Theatre credits include: *Assassins* (Best Production, Off-West End Awards 2011), *Iolanthe* (Union Theatre), Apollo Moran in the UK premiere of Teresa Devey's *A Wife To James Whelan* (New Diorama), Danny in *Hired* (Watford Palace Theatre), Time Out Critic's Choice *Northern Star*, and Lennox Robinson's *Drama At Inish* (Finborough Theatre). He has also appeared in *The Tudors* (HBO & BBC) and *Under The Hawthorn Tree* (RTÉ).

OWEN O'NEILL – MAN

Owen has written and performed seven one-man plays and has won a string of awards including three Fringe Firsts at the Edinburgh Festival, The Herald Angel award for Best Play and the LWT writers award for Best Comedy. Owen has toured his one-man plays in Ireland, America, Canada and Australia to critical acclaim. He has written and starred in three other plays, *Dead Meat*, *Travelling Light*, and *Patrick's Day* winning a Fringe First and the Edinburgh Festival Critic's Award for Best Comedy. In 2009 he adapted the *Shawshank Redemption* for the stage (Gaiety Theatre, The Wyndams Theatre). His debut feature film *ARISE AND GO NOW* was directed by Danny Boyle (*Slumdog Millionaire*), and screened as part of the BBC Film on 2 series. He has written and directed *The Basket Case*, which won Best Short Film at the 2008 Boston Film Festival. Owen also co-produced and had the original idea of staging the classic American play *Twelve Angry Men* using twelve stand-up comedians. The play received rave reviews and holds the record for the fastest sell-out in the history of the Edinburgh Festival. It went on to tour Australia and New Zealand and due to its success was followed the next year by *One flew over the Cuckoo's Nest* starring Christian Slater. This later transferred to the West End and ran for six months. His book of poetry, *Volcano Dancing*, was published in 2006. In 2010 Owen won Best Actor for his Off-Broadway performance as Nathan in his latest one-man play *ABSOLUTION*. The play also won Best Director for Rachel O'Riordan.

GARY LILBURN – OLD MAN

Gary trained at the Drama Centre London. Theatre credits include: Father Dewis in *Buried Child* (Leicester Curve), Tolstoy in *16 Possible Glimpses* (Abbey Theatre, Dublin), McLeavy in *Loot* (Hull Truck), Paddy in *The Hairy Ape*, and Pat in *The Hostage* (Southwark Playhouse), John in *Calendar Girls* (West End/Chichester Playhouse), Augie Belfast in *The Man Who Had All The Luck* (Donmar Warehouse). Also in London: *The Quare Fellow* (Tricycle/O.S.C.), *Hen House* (Arcola), The Golden Ass/*A Midsummer Night's Dream* (Shakespeare's Globe), *Buried Alive* (Hampstead), *The Weir* (Royal Court), *Angles and Saints* (Soho Theatre), *The Measels* (Gate), *Rhinoceros* (Riverside Studios), and Eugene O'Neill's *Desire Under The Elmes* (Shared Experience). Film credits include: *Gold, Dog Boy*, and *4 Conversations About Love* (Shorts), *Eden* (Clara Films), *Garage* (Whole Five Films) and *Veronica Guerin* (Merrion Films). Television credits include: *Pete v Life* (Objective Prods), *Doctors* (BBC), *I Shouldn't Be Alive* (Darlow Smithson), *Mrs Brown's Boys* (BBC), *Casualty* (BBC), *Whistle Blower* (RTÉ), *Single Handed* (Touchpaper TV), *Perfect Day: The Funeral* (World Prods), *Pulling* (Silver River), *Sea Of Souls* (BBC), *Grease Monkeys* (BBC), *The Bill* (Talkback Thames), *55 Degrees North* (Zenith), *EastEnders* (BBC), *Dalziel and Pascoe* (BBC), *My Family* (BBC), *McCready and Daughter* (BBC), *Fair City* (RTÉ) and *A Safe House* (BBC).

CREATIVE TEAM

COLIN TEEVAN – WRITER

Colin's recent stage work includes: *There Was A Man, There Was No Man.* part of *The Bomb: A Partial History* (Tricycle Theatre), *The Lion of Kabul* part of *The Great Game* (Tricycle Theatre), *How Many Miles to Basra?* (West Yorkshire Playhouse, winner of 2007 Clarion Award for Best New Play), *The Bee* and *The Diver* (Soho Theatre and NodaMap) both co-written with Hideki Noda, *Missing Persons: Four Tragedies and Roy Keane* and *Monkey!* (The Young Vic), *The Walls* (National Theatre, London), and *Alcmaeon in Corinth* (Live! Theatre). Adaptations include: *Kafka's Monkey* (Young Vic), *Peer Gynt*, (National Theatre Scotland and Barbican Theatre), *Don Quixote* with Pablo Ley (West Yorkshire Playhouse) and *Svejk* (Gate Theatre/TFANA, NY). Translations include: Euripides' *Bacchai* (National Theatre) and Manfridi's *Cuckoos* (Gate/Barbican), both directed by Sir Peter Hall, *Marathon* by Edoardo Erba (Gate), and *Iph...after Euripides* (Lyric, Belfast). Television includes: *Single Handed* (RTÉ & ITV), *Vera* (ITV), and forthcoming trilogy *Citizen Charlie* (RTÉ & Touchpaper TV). Colin has written over twenty plays for BBC Radio and is currently Senior Lecturer in Creative Writing at Birkbeck College, University of London. All his work is published by Oberon Books.

LUCY PITMAN-WALLACE – DIRECTOR

Lucy trained at Bristol Old Vic Theatre School. The UK premiere production of *The Burial at Thebes* by Seamus Heaney for Nottingham Playhouse 2005 earned her a TMA Best Director nomination. Lucy directed *Endgame* for the Liverpool Everyman starring Matthew Kelly. She revived *The Burial at Thebes* for two US festivals – Arts and Ideas in New Haven and the Spoleto Festival in Charleston. Her production of *Macbeth* played at the Lyceum Edinburgh and Nottingham Playhouse. Lucy runs Three Legged Company and has directed twelve productions, including *Dossier: Ronald Akkerman* (Gate) and *A Special Relationship* (co-production with York Theatre Royal UK tour including Traverse and Bristol Old Vic). Directing credits include: *Eastward Ho!* (Part of RSC Swan Season – Olivier Award for Outstanding Achievement 2003) reviving *The Lion, The Witch and The Wardrobe* (RSC Sadler's Wells), *Still Life, Unsecured* (National platforms), and *Waiting for Godot* with Kathryn Hunter

(National Studio). Freelance directing includes: *A Midsummer Night's Dream*, *The Blue Room* (York Theatre Royal), *Custer's Last Stand*, *Indian Ink*, *The Importance of Being Earnest*, *A Woman of No Importance* and *Way Upstream* (Salisbury Playhouse), *'Tis Pity* and *The Cherry Orchard* (RADA), *The Duchess of Malfi*, *As You Like It*, *Les Liaisons* (New Vic Stoke), *Macbeth*, *MSND*, and *Romeo and Juliet* (UK tours). Her most recent productions included *Jane Eyre* (BOVTS at Bristol Old Vic), *She Stoops* (Nottingham Playhouse), *Mary Stuart* and *Much Ado* (Malmö Sweden) and *Elektra* (Lund Sweden). Community projects include *The Ashampstead Dream*. Future productions include *Pygmalion* (Uppsala Sweden) and *Joking Apart* (Nottingham Playhouse and Salisbury Playhouse).

JESSICA CURTIS – SET & COSTUME DESIGNER

Jess trained at the Motley Theatre Design course. Her recent work includes: *The Holy Rosenbergs* (National Theatre, Cottesloe), *Another Door Closed* (Peter Hall Company), *Man of Mode* (RADA), *First Person Shooter* (The Door, Birmingham Rep), *The Rime of The Ancient Mariner* (The South Bank Centre/ Young Vic), *Mary Stuart*, *Much Ado About Nothing* (Hipp, Malmo Stadsteatre), *The Little Prince* (Hampstead Theatre), *Endgame* (The Liverpool Everyman), *Rhapsody* for the Royal Ballet Frederick Ashton Anniversary Celebrations (Royal Opera House, revived February 2007), *Dangerous Corner* (West Yorkshire Playhouse and West End), *Frankenstein* (Frantic Assembly and the Royal Theatre, Northampton), *My Zinc Bed*, *Follies*, *The Glass Cage* (Royal Theatre, Northampton), *She Stoops To Conquer*, *Burial of Thebes* (Nottingham Playhouse, revived September. 2007 at Nottingham Playhouse and at the Barbican PIT, then touring USA), *The Wizard of Oz* (West Yorkshire Playhouse), *Local Boy* (Hampstead Theatre), *Cinderella* (Oxford Playhouse), *Twelfth Night* (Open Air Theatre Regents Park), *Rookery Nook* (Oxford Stage Company), *Black Crows* (Clean Break at the Arcola Theatre and on tour), *Fantasy* (The Royal Ballet Frederick Ashton Anniversary Celebrations Lindbury studio), *The Daughter in Law*, *The Beauty Queen of Leenane* (Watford Palace Theatre), *Les Liaisons Dangereuses*, *Smoke*, *As You Like It*, *Once We Were Mothers*, *To Kill A Mockingbird*, *Once A Catholic*, *The Duchess of Malfi* (New Victoria Theatre, Newcastle under Lyme), *Absent Friends*, *A Woman of No Importance*, *Relative Values*, *Hysteria* and *Children of a Lesser God* (Salisbury Playhouse)

OLIVER FENWICK – LIGHTING DESIGNER
Theatre credits include: *The Holy Rosenbergs, Happy Now?* (National Theatre), *The Witness, Disconnect* (Royal Court), *My City, Ruined* (Almeida), *The Taming Of The Shrew, Julius Caesar, The Drunks, The Grain* Store (RSC), *After Miss Julie* (Young Vic), *Huis Clos* (Donmar, Trafalgar Studios), *Saved, A Midsummer Night's Dream* (Lyric, Hammersmith), *The Kingdom of Earth, Fabrication* (The Print Room), *The Beggar's Opera* (Regent's Park Open Air Theatre), *The Madness Of George III, Ghosts, Kean, The Solid Gold Cadillac, Secret Rapture* (West End), *The Kitchen Sink, The Contingency Plan, If There Is I Haven't Found It Yet* (Bush Theatre), *A Number* (Chocolate Factory), *Private Lives, The Giant, Glass Eels, Comfort Me With Apples* (Hampstead Theatre), *Restoration* (Headlong), *Far From the Madding Crowd* (English Touring Theatre), *Lady From The Sea, She Stoops To Conquer* (Birmingham Rep), *Realism, Mongrel Island, Pure Gold* (Soho Theatre), *Hamlet, The Caretaker, Comedy of Errors, Bird Calls, Iphigenia* (Crucible Theatre, Sheffield), *The Chairs* (Gate Theatre), *Hedda Gabler* (Gate Theatre, Dublin), *The Elephant Man* (Lyceum Theatre, Sheffield/tour), *Henry V* and *Mirandolina* (Royal Exchange Theatre, Manchester). Opera credits includes: *The Merry Widow* (Opera North & Sydney Opera House), *Samson et Delilah, Lohengrin* (Royal Opera House), *The Trojan Trilogy, The Nose,* and *The Gentle Giant* (Royal Opera House).

PAUL DODGSON – COMPOSER & SOUND DESIGN
Paul is a composer/sound designer, writer, radio producer and teacher. Theatre work includes music and lyrics for productions of *The French Detective and the Blue Dog, The Nutcracker* (Theatre Royal Bath), *Alice Through the Looking Glass* (Tobacco Factory Bristol), *The Importance of Being Earnest* and *Way Upstream* (Salisbury Playhouse). He has written and produced many plays for BBC Radio 4, including *Binge Drunk Britain – The Musical* and *Windscale.* Paul's latest radio play, *You Drive Me Crazy,* was transmitted on Radio 4 in January this year. Screenwriting credits include eighteen months as part of the *EastEnders* writing team and the drama/documentary series *Monsters We Met* (BBC 2). Paul recently finished a two-year post as Writer-in-Residence at Exeter University where he specialized in life-writing, a genre he now teaches internationally.

SIMON PITTMAN – MOVEMENT DIRECTOR

Simon is a freelance theatre director and movement director. He co-directs Rough Fiction, a multi-disciplinary company producing original touring productions and presenting pop-up theatre in London. He was trainee director at the Library Theatre Manchester 2006–2007. As director: *The Last of The Lake* (Rough Fiction/Brighton Dome & Tour), *The Love of The Nightingale* (Rough Fiction/pop-up Tour), *Not A Game For Boys* (Library Theatre Manchester), *The Interview* (Arcola), *Siblings* (The Gate), *Out of Sight* (Frantic Assembly/NYC). As movement director: *99...100, Mixter Maxter* and assistant movement on *365* (Edinburgh Playhouse/Lyric Hammersmith) – all National Theatre of Scotland. Associate direction includes the musical adaptation of *The Go-Between (WYP/Derby Live/ Royal & Derngate, Northampton)*, and *Floyd Collins* (Southwark Playhouse). He has also been an assistant director at Paines Plough and The Library Theatre and is a Creative Learning Practitioner for Frantic Assembly.

MICHAEL WHITE – EXECUTIVE PRODUCER

Michael has produced a range of award-winning work encompassing live art, film, theatre, installation, public art, education, photography, dance, new media and the visual arts in diverse settings such as pubs, clubs, schools, streets, canals, lidos, churches, naval bases, circus spaces, theatres, galleries and rural and city locations throughout the UK and Europe. Amongst others, artists and companies he has worked for include: RAMM in Exeter, Plymouth Arts Centre, The Red Room, Battersea Arts Centre, Watermans Arts Centre, The Albany Theatre, The Bridewell Theatre, Marisa Carnesky, Pacitti Company, Plugfish, Graeae Theatre Company, Oval House Theatre, Y Touring, and Duckie!

ROSIE CLARK – ASSISTANT PRODUCER

Rosie has been accepted onto the Stage One Producer Apprentice Scheme for 2012/13. She is Executive Producer for RAVENROCK Theatre Company, for whom she has produced *The Nymph* (Lyric Hammersmith) and *Jamie Blake* (Cockpit Theatre, Zoo Venues Edinburgh). She was the Associate Producer for Green House Theatre Company on their 2012 production of Philip Ridley's *Mercury Fur* (Old Red Lion, Trafalgar Studios). Rosie has also worked as a production assistant for Headlong Theatre's production of *Boys* by Ella Hickson and *Medea* by Mike Bartlett, and for the Lyric Hammersmith and their 2012 *Theatre In the Square* Festival (Lyric Hammersmith, Watford Imagine Festival, GDIF). In 2012 Rosie co-founded the Workshop Collective, organising and running workshops for emerging artists, and produced their devised piece *PlayGround* in association with the Cockpit Theatre (Cockpit Theatre, Standon Calling Festival). Rosie is an Associate Producer for Dugout Theatre Company, and produced/co-directed their production of *Bouncers Remix* (Hifi Club, Zoo Venues). In December 2010 Rosie stage managed *The Wind in the Willows* at Theatre 503. Other stage management credits include: *Hay Fever*, *Othello*, *Little Polly Puppet*, *Phaedra's Love* (which was selected for the National Student Drama Festival 2010), and ASM on West Yorkshire Playhouse's production of *'Tis Pity She's a Whore*.

ALI BEALE – PRODUCTION MANAGER

Ali has worked with Fevered Sleep since 2003, Projects include: *It's The Skin You're Living In*, *Little Universe*, *Still Life with Dog*, *On Ageing*, *The Bounce*, *The Forest*, *Brilliant*, *Stilled*, *An Infinite Line Brighton*, *And The Rain Falls Down*, *The Summer Subversive*, *Fleet*, *The Field of Miracles*, and *Feast Your Eyes*. Ali also works as a freelance Production Manager with work ranging from theatre to opera, dance and installation, including both national and international tours. Recent work includes: *Kingdom of Earth* (The Print Room), *Under Glass*, *Must*, *Performing Medicine*, *Sampled*, *Fantastic Voyage* (The Clod Ensemble), *Just Act*, *It Felt Empty*, *Missing Out*, *This Wide Night*, *Black Crows* (Clean Break), *Give us a Hand!* (The Little Angel Theatre), *Guided Tour* for Peter Reder (touring to Gijon, Arizona, Singapore, Bucharest and Moscow), *The Evocation of Papa Mas*, *The Firework*

Maker's Daughter, Aladdin, Playing the Victim, A Little Fantasy, Shoot Me in The Heart (Told by An Idiot), *Gumbo Jumbo, Troy Town* (The Gogmagogs), *The Ratcatcher of Hamlin* (Cartoon De Salvo), *Oogly Boogly* for Tom Morris and Guy Dartnel, *Throat* (Company FZ), and *Arcane* (Opera Circus).

BETH HOARE-BARNES – STAGE MANAGER

Over the last few years Beth has been lucky enough to work on many diverse projects, including digital operatic monsters (*Where The Wild Things Are* and *Higglety Pigglety Pop!*, Aldeburgh Music), trees, leaves and conkers (*The Forest* on a UK tour and at the Sydney Opera House, Fevered Sleep), aerial artists and South Asian dancers (various projects with Akademi), puppets (*The Magician's Daughter*, Little Angel), and white paper suits (*Reykjavik*, Shams). Other companies include Talawa, Kali Theatre, Playing On, Shakespeare's Globe, Theatre-Rites, Regent's Park, and Unicorn Theatre for Children. Previously Beth spent four years in the US studying and working as a Stage Manager and Lighting Designer, where she received an MFA and designed professionally in New York, Cleveland and Columbus.

THE KINGDOM

Colin Teevan

THE KINGDOM

OBERON BOOKS
LONDON

WWW.OBERONBOOKS.COM

First published in 2012 by Oberon Books Ltd
521 Caledonian Road, London N7 9RH
Tel: +44 (0) 20 7607 3637 / Fax: +44 (0) 20 7607 3629
e-mail: info@oberonbooks.com
www.oberonbooks.com

A catalogue record for this book is available from the British Library.

PB ISBN: 978-1-84943-487-4
Digital ISBN: 978-1-84943-591-8

Cover image: Members of the West Limerick Brigade, Old-IRA
arrested by British Forces during Irish war of Independence March
Cover design: Michael Windsor-Ungureanu

Characters

YOUNG MAN

MAN

OLD MAN

Acknowledgements

In the initial instance I am indebted to Gerry Harrison's obituary of John Murphy in the *Guardian* of 23 January 2009. Other works which proved extremely helpful were Dónall Mac Amhlaigh, *An Irish Navvy: The Diary of an Exile*; Ultan Cowley, *The Men Who Built Britain*; Catherine Dunne, *An Unconsidered People*; and the world of the London Irish evoked in the novels of J.M. O'Neill. I am grateful to all those who took the time to talk to me and tell me of their experiences as Irish migrant workers in the 1950s in Britain. I am deeply indebted to Aisha Zia who was a tireless researcher; to Lucy Pitman-Wallace who encouraged, coaxed and cajoled this play through its many stages of development; the actors who took part in the various workshops; to Joe and all at Curtis Brown for their continued support; and to Madeline, Oisín and Lily for everything.

1.

Three men, a YOUNG MAN, a middle-aged MAN and an OLD MAN dig.
They dig throughout.

The YOUNG MAN alternates between erratic bursts of unfocused energy
and resting. He wears an old workman's suit, a hand-me-down from
another era. It is too small for him.

The MAN works steadily and powerfully with the practised ease of
someone for whom this is not the daily grind but a place where he can
demonstrate his superiority. He wears a 1970s suit that, while still that
of a working man, is tailored to fit. He takes care to keep it clean and
orderly.

The OLD MAN wears a suit similar to that of the Man but it is old and
worn and now too large for him. Though blind he works automatically
from a lifetime of habit.

The words emerge from the rhythm of the work, and the breathing required
to accomplish the digging sets the pace.

Lights rise to discover the men working.

YOUNG MAN
'Out of my road, tinker,' says the man –

MAN
Bit further on today.

YOUNG MAN
At the crossroads above Threemiletown –

MAN
Wants it all moved by close of play.

YOUNG MAN
Been walking the roads since dawn,
Ten, fifteen miles beyond *Ros na Gréine*,
Heart light, free at last.

MAN
Be through the other side soon, they say.

YOUNG MAN
Five of them there are all told.

MAN
Then, the open road.

YOUNG MAN
I just stop and look at him, stand my ground.

OLD MAN
Go on believing, if it helps,
Telling yourself stories,
If it helps put down the day.

YOUNG MAN
But no mistaking who was boss.

MAN
Sun on our backs.

OLD MAN
One road's the same as another, when you're digging it.

YOUNG MAN
Four mill round the fifth like nervous dogs.

OLD MAN
One hole the same as another when you're in it.

YOUNG MAN
His eyes are dark, his hair black,
But tell-tale grey about the sides. Dyed.
And his heels are raised. The vanity of little men.
He carries a spade.
'What?' I says.
'You heard,' he says, 'I won't say it again.'
'A travelling man, I might be,' I says,
'But I'm no gypsy, mister.'
'Your feet are bare and swollen, fella,
You look like a tinker
Or the bastard of a tinker's whore to me.
And I should know,
I've ridden every one that's set foot in the county.'
The others laugh on cue.

'I'll admit it, mister, I am poor,
But this is a public thoroughfare,
And a free country, or so they say.'
He laughs this time and shakes his head.
'And I did not escape that school,' says I,
'To be told what to do by any man no more.'
'Is that so?' he says.
'It is,' says I, 'I'll not move on point of principle.'
'Point of principle, do you hear?
A lad who can't afford a pair of shoes,
Thinks he can afford a principle.
Out of my road,' he says, 'shit on my shoe!'
'It's you who's in my way, old man,' I say.

> *The YOUNG MAN brings down his pick resolutely.*

OLD MAN
Burn yourself out, swinging that way –

YOUNG MAN
(Ignoring him.) The others start to circle me.

OLD MAN
Like the hammers of hell –

YOUNG MAN
Barging at me with their shoulders –

OLD MAN
Slow and steady.

YOUNG MAN
Softening me up for him, they think.

OLD MAN
A lifetime of this ahead of you.

YOUNG MAN
If I learnt one thing at that school, I learnt this.
Don't rise to them, don't respond –

OLD MAN
Slow and steady –

YOUNG MAN
Stand your ground,
Leave them guessing your next move.

OLD MAN
Let the pick do the work.
Let the shaft slide through your hand –

YOUNG MAN
Let him think you'll take the beating
With the butt-end of the spade that he's swinging –

OLD MAN
Then let the head's heft carry it through the air,
Down –

YOUNG MAN
But as it comes down I catch it,
And I have it off of him,
And it's me who's doing the swinging.

OLD MAN
Hit the same spot again and again –

YOUNG MAN
And I've felled one –

OLD MAN
It will soon weaken.

YOUNG MAN
Two, three, more fall to the ground,
Then off they scurry, like rats down a ditch.
And their boss, the brave custodian of the way,
Who'd beat a pinned man with the butt-end of a spade,
Is off and running too,
Towards the nearby church for sanctuary.
But I chase after him, and catch him,
Just as his hand's upon the handle,
And haul him by the collar from the door,
And throw him to the earth.
And in that graveyard above Threemiletown
I repay his coward's blow,
Not with the butt-end, but with the blade.

Beat.

OLD MAN
The hardest earth in the end shall yield.

YOUNG MAN
I take his boots from off his feet,
Check his pocket for loose change,
A solitary brass penny's all I find,
And walk back to the crossroads,
Where I sit and ease the dead man's boots
Over my swollen feet.
A shadow falls across me.
'Mister,' a voice says nervously.
One of his dogs has crawled from the ditch.
'What? Is it more of the same you're after?'
I says without looking up.
Unsure whether to stay and fight, or go,
I watch his shadow shift from toe to toe.
'How about we let fate decide?' says I.
And take the dead man's penny out.
'Heads, I kill you; harps, I let you go.'
He's silent, dumb with fear.
I toss the coin in the air.

YOUNG MAN watches it rise and fall in his memory.

YOUNG MAN
'Looks like you're in luck today, fella.'
Laces tied, I take the spade, stand and say,
'It's you who's in my road now, tinker, out of my way.'
He stands aside for me.
I take the road eastwards towards the sea,
And England.

2.

MAN
Every day, a bit further along. And after this –

YOUNG MAN
(Heard it before.) The open road, the sun.

MAN
One step ahead, that's what I've always done,
One step ahead of the game, not behind.

The MAN resumes digging.

YOUNG MAN
When I get off the boat in Holyhead,
I don't even have the money for the train –

MAN
How I made something of myself –

YOUNG MAN
So I set off on foot to London –

YOUNG MAN resumes digging.

MAN
From nothing. Walked to London barefoot.

The OLD MAN remembers.

YOUNG MAN
Near Daventry
I meet a fella from the Kingdom.
The Horse they call him.

MAN
Horse? The Horse O'Sullivan?

OLD MAN
Old Horse.

YOUNG MAN
Says there is a start on a tunnel they are digging.
Eight months we slave under the ground,
Under a string of sodium lights,

Can barely see the hand in front of us,
Our eyes that blinded by black dust,
Our lungs choked with it, and our ears,
Always ringing to the sound of pick on stone
And men's cries.
Until one day I says to Horse,
'I've had enough,
It's been months since I've seen the sun – '

MAN

Make something of yourself, as the man says.

YOUNG MAN

'Watch my back, I'm doing a skite.'

MAN

Free of your past, you can be
Anything you want to be.
Then, the wallet full, return home the man.
They'll respect you then.

OLD MAN

Respect you? They'll not know you.
We're all dead men to them that's stayed behind.

YOUNG MAN

'But what about the ganger?' asks Horse.
'They're blasting, they won't notice that I'm gone.'
I skulk back through the shadows,
Back along the line of men,
'Just need to get that thing for yer man,
The thing for the thing he's got to do – '
Then burst of light!
And I scramble up a grassy bank to where –

OLD MAN

The air smelled sweet, and birds sang.

YOUNG MAN

Aye, Old Man, the air is sweet,
And there are birds and all.
And there, amongst the trees
A statue of Our Lady in black stone.
A shrine.

OLD MAN
Our Lady of Succour.

YOUNG MAN
And under her, a pool of holy water.
I wash in it and drink from it.
And in front, a clearing of cut grass.
I lie on my back and close my eyes.

OLD MAN
And the sun shone down from the bluest sky.

YOUNG MAN
And when I open them, I see
That there's a woman standing over me.
The sun behind her, I can't make out her face.
She seems some kind of divine being.

OLD MAN
Our Lady of the Road herself.

YOUNG MAN
'No, don't look,' she says.
She puts her hand over my eyes.
'You should not be here,' she says.
Her voice, I hear it now, a voice from home,
Rich and flowing, a half-remembered song.

OLD MAN
This is Our Lady's shrine, she said,
A sanctuary for women.

YOUNG MAN
I bend to no man's, nor no God's will but my own.

OLD MAN
Brave boy.

YOUNG MAN
I am a man.

OLD MAN
You've the makings of one at least, she said.

YOUNG MAN
Still she covers my eyes, but I sense her smile
In the warmth of her breath upon me.

OLD MAN
You should go. You should leave this place.

YOUNG MAN
No, I say.

OLD MAN
Stubborn boy, let's make a deal then so.

YOUNG MAN
What kind of deal? I say.

OLD MAN
If you can tell me who I am, she said,
I'll accept you are man,
And grant you leave to see me.

YOUNG MAN
And how might I guess who you are?

OLD MAN
A riddle, she said.

YOUNG MAN
Go on then, I'm good at them.

OLD MAN
My mother is my father's child,
And my mother's son my father,
If I believe this is no lie,
Tell me stranger who am I?

Pause.

YOUNG MAN
Sure that's easy, I say eventually,
You're a good Christian, that's who you are.

Beat.

OLD MAN
You guessed. You'll wish you never had done.

YOUNG MAN
No, Old Man, you're wrong.
She says, 'You guessed, tell me how.'
And I say 'Because Our Lady is Our Father's child,
Her son one with God the father.
And that's what a Christian must believe.
So you see…'

He laughs. Beat.

And she takes her hand from off my eyes.
And I whisper 'No, leave me blind.
Let me imagine you still a little while.'

Beat.

'So tell me from where it is you come?' I say.
'From across the water just like you.'
'No, here, where are you staying?' I say.
'The convent up beyond.'
'Jasus! You're a nun?' I say.
'No, I needed refuge…sanctuary.
And in return I help them tend the shrine.'
A bell sounds.
'I must go now so tell me quick,' she says,
'What is it you'll be wanting for your prize?'
And I say 'I'll be wanting you
To meet me here tonight.'

Beat.

OLD MAN
Our Lady of Succour!
Lady of the suckers!
Do you watch over the world laughing,
As the young man sets out at dawn of day,
Thinking he makes his own way,
Only to fall into the trough or hole or ditch
You had fate dig for him?
Contrary bitch!

Beat.
To accept, or not to accept,
The only choice allotted man.

3.

YOUNG MAN

What is it happened to your eyes, old man?
Was it the cement, the dust?
They say that's the bitch.

OLD MAN

Greensheen! I still know how to wield a pick.

YOUNG MAN

Fair dues, Old Man, fair dues,
But you'll not find me digging all my life.

OLD MAN

You're right, the way I hear you swinging at it.

YOUNG MAN

I've got plans. Make something of myself.

MAN

All moved by close of play.

YOUNG MAN

I'm out of here, when I've the money saved.

MAN

One step ahead, that's how I've done it,
One step ahead of the game, not behind.

They resume digging.

MAN

I tell the Prophet meet me at the yard at five
Before the place begins to teem with men.
And when at last he does arrive,
Pale, hungover, bleary, I ask him:
Do you know how I built all this? This company?
Because I can spot an opportunity
Out of the corner of my little eye,
And cost every nut and bolt of it,
In the blinking of that eye,
To a margin give or take of three per cent.
So I can see when the costing and the costs are out.

What is it, Prophet, is it dead men?
Do the gangers think they can cheat me so easily?

Beat.

Speak to me, Prophet,
People think because you're blind
That you don't hear, but you hear well, I know you do.
You hear them bragging in the bars,
What strokes they're pulling and on who.
Tell me, Prophet, tell me, I want to know.

OLD MAN
You don't.

MAN
What?

OLD MAN
You think you want to know, but you do not.

MAN
Are you forgetting, Prophet, who keeps you in beer?
Pays for your ear to be kept close to the ground?

OLD MAN
Bear the extra costs, you don't want to know.

MAN
This is my company. They work for me.
I've given them jobs, training, a livelihood,
They owe me, you all owe me.

OLD MAN
We work for you. You pay us. No one's owed.
But I'll not be the one to tell you what's being said.

MAN
Why not?

OLD MAN
Because I fear your temper.

MAN
You are right to.
I smack him across the ear for good measure.

Call yourself a Prophet?
Didn't see that coming, did you?
Where's your loyalty fella?

OLD MAN
Is it not less loyal to tell you,
That which would destroy you?

MAN
It will take more than you to knock me down.
If you don't tell me, I'll blame you.
It's you and your wife who'll suffer.

OLD MAN
My wife is dead.

Beat.

MAN
I hadn't heard.

OLD MAN
But it's yours about whom you should be concerned.

MAN
Mine? What of her? What is she to you?
You're not fit to touch her feet.
Talk or you'll join yours in the grave.

OLD MAN
What is the point? You'll not believe me if I do?

MAN
Try me.

OLD MAN
These dead men are but the symptom,
It's you who is the cause.

Beat.

YOUNG MAN
The only light is that of half a moon.

MAN
Me?

YOUNG MAN
A figure stands beneath the statue alone.
Tall and slender, in silhouette.
She smokes a cigarette.

MAN
You're not a prophet fella, you are mad.

YOUNG MAN
I see now she's older than me.

MAN
Have they cut you in on this, the others?

YOUNG MAN
But for that, grown into her beauty.

MAN
Concrete Mick, Horse, or Elephant Seán?

YOUNG MAN
I stand and look at her a time.

MAN
No, not Horse –

YOUNG MAN
And in this ghostly light, she seems to me –

MAN
And Elephant is family.

YOUNG MAN
A queen.

MAN
So it has to be the gangermen.
You think they'd be better friends than me?

OLD MAN
I've nothing to gain from any of this,
And much to lose, whichever way it falls.

YOUNG MAN
'So,' she says, without turning,
'Have you have come to claim your prize?'

OLD MAN
You demanded I tell you –

YOUNG MAN
She looks at me.

OLD MAN
I've told you.

YOUNG MAN
Her eyes –

MAN
You are blind, but blind like them –

YOUNG MAN
Blue, like the sea in summer in the west –

MAN
Blinded by jealousy, by envy,
Each one of you thinks you could've been me.

YOUNG MAN
She looks at me, right into me, and knows me.

MAN
But I did it. I walked to London in my bare feet.
I built all this from nothing with these hands.
I've built the roads and rails,
The tunnels, pipes, the veins –

YOUNG MAN
Knew me better than I knew myself.

MAN
The arteries of this god-forsaken land.

YOUNG MAN
'And what's my prize?' I asks her.

MAN
You, for all your blind-man's wisdom, couldn't –

YOUNG MAN
And she says, 'Your prize is me.'

MAN
Nor them –

YOUNG MAN
'Why me?' I ask her.

MAN
Nor any other man, but me!

YOUNG MAN
'Because you solved the riddle,' she says.

MAN
I did it!

YOUNG MAN
'Because you came back for me.'

MAN
I did it!

YOUNG MAN
'A queer audition for a husband,' I say.

MAN
I see what needs to be done, and how.

YOUNG MAN
'As good as any other,' she looks at me.

MAN
I see where a man's weakness lies.

OLD MAN
Except your own.

YOUNG MAN
'And I can see,' she says, 'you're a strong man,
A man of ambition.'

MAN
But now you and those shit-shovellers,
You think you can take it from me? Not openly, no,
But like cowards, penny by brass penny,
Mucky hands in the till. Think I cannot see?

YOUNG MAN
'You want to leave this sanctuary?'

MAN
This time I knock him to the floor.

YOUNG MAN
'I was running from something,' she says,
'But that something is no more – '

MAN
If it's dead men you're claiming for,
It's dead men you will be.

YOUNG MAN
'Take me with you,' she says –

MAN
On all fours, like a wounded beast he whines.
That is all you are, a poor blind animal.

YOUNG MAN
'If you want me.'

MAN
All any of you are without me,
Lost beasts bleating in the rain.

OLD MAN
You mock my blindness, yet you are blind
To yourself, and to the woman that you married.

YOUNG MAN
I look at her still.

OLD MAN
You won't be able to look at her when you know.
You'll pray for blindness.

YOUNG MAN
She looks at me.

MAN
Out! Out! Pig, filth, shit on my shoe!
I'll tear your tongue clean out of you

If you so much as breathe her name again.
I'll rip this evil out of here, if I have to tear down
These very walls. I built my kingdom, brick by brick,
My kingdom's me. I stand aside for no man.
I throw the blind beggar down the stairs.

YOUNG MAN
Something in me, long-closed, opens.
A house, a home, a place,
All that I have never known
Seems here, in this face,
In her.
And she says 'I'm yours, if you'll have me.'
And puts her hand upon my arm.
The ground beneath us opens,
The earth enfolds us in her dark womb.
Our bodies, now one,
I hear the same heart beat in our breast,
In hers, in mine.
This cocoon, the whole world.
Just us.
I hold her.
She, me.
'So,' she says, 'what's it to be?'
And I say 'I choose you'.

The OLD MAN lays down the pick.

OLD MAN
The coin that decides our fate
Is cast and called by another hand.

YOUNG MAN
What? Like God? Have you not heard?
This is the modern world?

OLD MAN
The Gods exist,
Most terribly they do.
That they might grant me some understanding,
Some consummation, in the end.

The YOUNG MAN scoffs. The OLD MAN sits, wearily.

4.

MAN

I find her in her rooms alone.
She sits at the mirror, in a silk dressing gown,
Brushing her hair, preparing for the day.
I stand behind her, smell her hair,
Her perfume.
I am helpless to resist her.
Even after all these years, helpless.
I just stand and watch her.

OLD MAN

Some consummation in the end.

MAN

'What is wrong?' My wife asks without looking up.
I go to her.
My hand slips down her dressing gown,
I trace her breast.
'They're up to something,' I say,
'Think they've something on me,
Something so big I won't go after them.
And the Prophet's in on it too.'
'What could they know about you,
That you don't know yourself?'
She puts her hand upon my chest.
'Raised in the industrial school,
It's not like you have family
Who could return to embarrass you.'
'But you do,' I say,
'Your brother Seán's changed of late.
I used to rule this place with a fist of steel,
And he was happy to see me run it so.
They were all scared of me, even him.
But now he treats me with familiarity.
It breeds contempt amongst the other men.
This is his plan, I'm sure, he wants it for himself.
All that I've built from nothing.'
'Go to him,' she says, 'and don't hold back because of me.
What is my family to me now?' she says,

'They had me sent away to hide their shame.
To protect the good name they never had.
You are the only family to me now.'
She kisses my hands, and leads me to her bed.
'Come, come to bed and fill me,' she says,
'Then –

> *YOUNG MAN lights a cigarette, inhales.*

MAN
Then go see to my brother Seán.'

5.

YOUNG MAN

'What are you going to do?' asks Horse.
'I'm going to drink that pint you're going to buy me,
That's what I'm going to do.
Remember, we're celebrating, pal.'
'When *it* comes?' says Horse, 'what will you do then?'
Nodding to the barman all the same.
We'd got our cards from the job in Daventry,
And walked on down the road to London.
Me and Horse and her. We found rooms
In a kip in Kilburn and touted round for work.
But it was winter and starts were scarce.
Her twin, the Elephant Seán,
A timekeeper for a John Bull firm,
Got us some shifts, but most days
We were pulling the devil by the tail.
'I'm going to make him proud of me, when he comes,
That's what I'm going to do,' I say to Horse,
'Give him the life that I could never have.
A home, education, the works.
He'll be the luckiest lad in this godless realm.'
'You're so sure it's going to be a boy?' says Horse.
'What else could it be, with me as his father?
He'll have a mother too.'
I take a drink.
'True, being raised in that industrial school,
I forget some people do have mammies too.'
'Aren't you the self-made man!'
'Not fully made, not yet, but I have plans.'
'You'll need them,' says Horse,
'The missus, the landlady at the digs won't keep you,
Once the little one is born.
So what's this plan of yours?'
'Set up on my own.'
'Against the John Bulls?' says the Horse,
'But they've got all the contracts sewn.'
'Do the sums. What do we get paid?
A few pounds a day tops.

Now count the skulls,
Then times that by the days a job might take.
Do you think that's what it costs
To lay some pipes or dig a trench?
There's half again or more for the boss,
Though you'll never see it in his ledgers.
There's subsistence for the workers,
For food we never see, "wet days" claimed
While we sweat our skins off in the sun,
And dead men, ghosts on the books,
Whose wages are shared between every crook
From the ganger to old John Bull himself.'
'But them that give the contracts,'
Says the Horse, 'they also get their cut,
And they're not the types you'd run into
At the *Galtee More* in Cricklewood.'
'No, that's true.
That's where her brother Seán comes in.'

MAN
Elephant! Elephant! Elephant Seán!

YOUNG MAN
The timekeeper with the John Bull firm? asks Horse.
'Aye, him. He knows them all.
And it's his job to keep them sweet,
Make sure they all play ball.'

MAN
I found him in the lorry yard,
Yarning with some men.

YOUNG MAN
He knows who's who
And what their prices and their weaknesses are.'

MAN
Do I pay you to stand and talk and smoke?
Back to work, you dossers.

Reluctantly the YOUNG MAN picks up his shovel.

YOUNG MAN

'Perhaps. But are you sure that you can trust him?'
'Why wouldn't I?' I say –

MAN

Elephant makes to leave as well.

YOUNG MAN

'He's family.'

MAN

A word with you Seán.

The YOUNG MAN returns to digging.

MAN

What was it you were talking of
With the men just now?

OLD MAN

Just blather, he said, you know,
Ear to the ground, who's pulling what stroke where.
Isn't that the way we always worked?

MAN

But what I can't work out Seán
Is what you take me for,
A coward or a fool?

Pause.

OLD MAN

Neither, brother, the Elephant said,
Half-smiling, half-sneering.

MAN

Don't call me that, I say.

OLD MAN

You are my sister's husband, he said.

MAN

But I, I have no brother, I say.

OLD MAN

The self-made man, I sometimes forget.

MAN

I'm asking you.

OLD MAN

Why don't you tell me straight then so
What it is you accuse me of?

MAN

I'll tell you then, I say, if you're so keen to know:
Of ingratitude, of theft,
Of putting dead men on the books,
Of betraying me, betraying the principles
We once stood for.
You were supposed to keep the gangers straight,
Now you work with them to cheat me.

Beat.
You don't deny it?

OLD MAN

Some things, said Elephant, cannot be helped.

MAN

Still he wouldn't look at me.
We were going to do things differently, I say,
A fairer deal for all the men,
That's how we got where we are today.

OLD MAN

We got where we are by luck, brother,
And luck changes.

MAN

It's not my luck that's changed, I say, it's you.

OLD MAN

Your problem's not with dead men, he said,
But with a dead man in particular.

MAN

What man? I ask, has there been an accident?

OLD MAN

You could say.

MAN
Who?

OLD MAN
Boss Carbery, my father, said Elephant.
Or should I say, the father of your wife and me.

MAN
What of him? I never met the man.
He died years ago, back home, that's all I know.

OLD MAN
He did, said the Elephant,
But did you never wonder at the circumstances?

MAN
And now he sneaks a glance at me.

OLD MAN
Slain he was, he said, by a gang of thieves.

MAN
So? What is this to me?

OLD MAN
At a crossroads beyond our town.
The blade of a spade cut his head in two.

Pause.

OLD MAN
The killers were never found, he went on,
Went to ground as quick as they'd appeared.
Some suspected them that had been with him.

MAN
And you, I say, where were you that day?

OLD MAN
I'd been sent to England long before.
When I came home for the funeral,
I heard the story from them then.
They said that they'd been beaten too,
They talked with fear of this murderous gang.
They swore it was the curse come true.

MAN

The curse? I say.

OLD MAN

The curse the tinkers put on him.

MAN

Tinkers curses! Bog disputes! I still don't see
What all this has to do with me?

OLD MAN

A few months back, the Elephant said,
This fella from the Kingdom came to me,
Angel, they call him, the Angel Sweeney,
No longer young or fit, down on his luck,
But an old friend of my father's.
I gave him a start on the Southwark site.
Last week, Elephant went on, you were out,
You saw some young scelp scratching in a ditch,
You jumped in to show him how to wield a pick.
"Slow and steady, let the weight do the work,"
You advised him. The others stood and marvelled,
"You'd never see John Bull risk his suit
To teach a greensheen how to dig a trench."
But the old fella turns to me and says,
"That's him."
It is, says I, it is the boss.
"Boss he may be,
But he's the one who killed your father.
The one who struck the fatal blow."

Beat.

MAN

What? The word of some old fella off the boat?

OLD MAN

He said you felled him with a spade,
Then took his boots for your own.

Pause. The MAN is rattled.

MAN

And the dead men? I ask him.

OLD MAN

Some things cannot be helped, he shrugged.
The ganger was listening,
He threatened to tell if I did not cut him in.
You can't afford such rumours spreading.

MAN

But if your concern for me was such,
I ask him, why not come to me?

OLD MAN

I didn't want to trouble you, he said.

MAN

So you thought it better to betray me?
Listen Elephant and listen good,
I've not lived a blameless life.
No man is without sin, without regret.
But I'll not have lies told of me,
Especially by a man who takes my coin.
I was never part of any gang of thieves.
I never killed yours nor no man's father.
So, go tell this fella from the Kingdom that,
And if he ever wants to work
In England, Scotland or in fucking Wales
He'll keep his tall tales to himself.

Beat.

She must have been watching us from her window.
She came to us now to intervene.
'What were you two talking of?' she says.
'Just yarning,' says Elephant, straightening his suit.
'What about?'
'About our father,' says Elephant,
'About the curse the tinkers put on him.'
'What of that?' she says.
'Maybe it is all just superstition,' says Elephant,
'Maybe we can let all the dead men lie, so.
Eh brother?'
And winking like a Soho pimp he goes.

6.

MAN

Must keep going. Further, further on,
Break through the other side soon.
Then, the open road, the sun.

YOUNG MAN

'Where are you going?' she asks.
'Out,' I say.
'Out where?' she says, 'Night after night
You leave me on my own in this damp room,
No money for the fire, while you
Spend the little that we have on beer.
I'm having your child.'
'I'm doing it for him,' I say to her.
'What? What is it you're doing?'
'Later, when it's done.'

OLD MAN

You can't trust him, my brother Seán, she said.

YOUNG MAN looks to OLD MAN.

YOUNG MAN

Aye. She says, 'You can't trust him, my brother Seán.
And we should have no secrets from each other.'
'After tonight, we'll have none, I swear,
But for now…'
'No,' she says, 'don't leave me.'

MAN

What is this curse Seán talked of?
I ask her when he's gone.

OLD MAN

Have we not left the pookas of the past
On the stone floors of our cold cottages?

MAN

I need to know. No secrets, remember.

OLD MAN

No, no further today.
Dig no more.

MAN
I must get to the truth. Break through.

Beat.

OLD MAN
I'll tell you so, she said,
But all this so-called curse proves,
Is that curses themselves cannot be true.
My father, the so-called 'Boss' Carbery,
Was the devil.
Born of the bog, bog dark, bog dirty,
He terrorised the homeland.
And men looked up to him for that,
Or thought it better to be his friend than enemy.
One year at the horse fair, he saw a girl.
A wild gypsy child, black hair, blue eyes, white skin.
Something in her took hold of him.
He had to have her.
But she did not want him,
She ran away when he tried to talk to her,
She laughed at him when he asked her for a dance.
So, he and his men waited for her by the road
As she walked home.
They caught her and held her down
As he had her there in the ditch.
Next day her father came round, her in tow,
To seek satisfaction.
But no man got satisfaction from my father,
Nor woman either. "Off with you tinker, shoo,
Or I'll have you beat for good measure too."
And so the tinker spat and cursed him,
Said he'd die at the hand of his own son,
And that the curse would be passed on
Through the generations.
Then he pushed his daughter towards Boss Carbery.
"She's yours now, soiled goods, no good to me."

MAN
And this girl? I ask her.

OLD MAN
Died. Died in childbirth, she told me.

MAN
She had a child? I say.

OLD MAN
She had two, she told me, a daughter and a son.
Myself and my brother, Seán.

Pause.
But my father feared that curse,
That's why later he sent first my brother
Then myself, here to England.

MAN
Both?

OLD MAN
No, no further on.

MAN
I'll dig, dig until it's done.

Beat.

OLD MAN
That, that doesn't matter, she said, all that matters is,
That he was wrong to fear the curse.
It was a group of strangers killed him
At that crossroads above Threemiletown.

The MAN stops. Pause.

OLD MAN
(Sardonic.) You see, you need fear nothing from this curse.

7.

YOUNG MAN

We were to run into them in Soho,
Horse and me, out on the jag,
Just bumping into them coincidentally.
'Well fancy meeting you here Seán.'
'Seán? Your wife's brother is it so?
By the look of you you'd never know,' chimes Horse.
I do the honours though they know each other well.
'Seán, The Horse O'Sullivan; Horse, the Elephant Seán.
And who's this you're with?'
'A client I'm entertaining for John Bull,' says Seán,
'Mr Jackson from the Council's board of works.
The Council's our most valued customer
And there's a new contract up for grabs,
So John Bull told me show him a good time.'
'Well we're out after that same good time and all,
Celebrating a new contract we are getting.
So why not join us, make a night of it.'
'I'm not sure,' says Jackson, 'it's late.
My wife will be waiting, I need to get home.'
'Who wears the steel-caps in your house?' says Horse. 'Come on,
There's still a drag or two in this fag-end of an evening.'

MAN

'Threemiletown?' I say quietly.
'What of it?' she says.
'How was it he was killed?' I ask.
She tells the same story as her brother,
The story of the gang of men.
'What does it matter?'
'Seán says there's some fella on the sites,
Says I was one of them, those men.'
She looks at me confused, then laughs,
'Then Seán or this fella are raving mad.
And you worse for believing them.'
She stops.
'You don't believe them?' she says.
'I was never part of any gang that killed a man.'
'Well then.'
'But Threemiletown,' I say…

YOUNG MAN
Pints are drunk that night,
And the talk is mighty.
We lay it on thick for Jackson's benefit.
And when last orders are sung out,
I nonchalant say there's this club hereabouts.
Jackson, bleary, says no, he really must go,
His wife…
'Let her sleep, fella,' says the Horse,
'You'll only go waking her at this hour.
No worries fella, this one's on us.'
'How rude of me,' says Jackson, 'but of course.'

MAN
'What did he look like, your father?'
'I'd not seen him for years before he died,' she says,
'Like I said, I was in England at the convent.'
'Tell me what you know.'

OLD MAN
Let it go. Let it all go.

MAN
'He was dark,' she says.
'Dark how?' I say, 'dark hair?'

OLD MAN
Greying about the temples in later years, she said.

MAN
Tall or short? Tell me, I say.

OLD MAN
He was not small, she said.

MAN is relieved.

OLD MAN
But then, she said, he wore raised-heels to appear so,
And dyed his hair to appear less grey.

MAN looks at the OLD MAN.

YOUNG MAN
'Now's the time, that one there,'

Elephant whispers in my ear,
'She's game for a few quid, I can tell.'
The music blares. Jackson cannot hear.
'But,' I says to Elephant unsure,
'I wanted to do things proper,
To cut all the back-handers and middle-men,
Who bleed us of our wages. I have principles – '
'Principles are all well and good, fella,
But they trip you up in a game as tight as this.
If you want to win your kingdom here on earth
This is it, and this is how it's played.'
'If you know how it's done,' I ask him,
'Why don't you do it on your own?'
'Because I know what I am and what I'm not.
And I'm a courtier and not a king.
Go on,' says he, gesturing, 'she's the one.'

OLD MAN

What is it, my love? she said, what is it you fear?

MAN

I fear that I have called down this curse upon me.

OLD MAN

(As himself.) What is it, man of action? Of principle? Of truth?
Does your estimate not compute?
Do you begin to see the yawning gap
Between the costings and the cost?

The MAN looks to OLD MAN.

YOUNG MAN

The tart is standing by the door,
Back to me, shoulders bare, skin pale and clammy,
All make-up, fake jewelry, cheap perfume.
'Hello gorgeous!' she turns.
'There's something I'd like you to do for me,' I say.
I wave a note, Horse's and my pooled resources,
Next week's food. She looks me up and down,
A butcher eying a side of beef.
'For you? Sure.' she smiles, her teeth are bad.
'For me,

But to him,' I say and point.
She looks across to where Jackson sits.
'Who's that?' she says, 'Is that your Dad?
He'll be more.'
'That's the offer, or I'll ask another.'
She shrugs. The night is slow,
She takes the note and goes.
And soon she leads Jackson to the floor.
They dance.
She whispers something in his ear,
Then off they go to a room upstairs.
'Lucky man,' says Elephant.
'Poor sap,' says Horse.
'I'll wait here,' I say, 'you two clear off,
I don't have the cash to keep you in beer all night.'
'If he tells John Bull what I've done – '
'He won't, he won't say a word, trust me Seán.'
And they are gone.
I wait.

Beat.

MAN
'What is it?' she asks again.

OLD MAN
One step further on is to step –

MAN
'Tell me my love, we are one.'

OLD MAN
Into the boneyard.

MAN
At school when he beat us, the Brother would jeer,
'If you knew where you came from
You'd not walk so proud, so tall.
But I know you, and who all your fathers are,
Corner-boys, tinkers, thieves and drunks.'
Over time the boys would begin to believe
This estimate of themselves. But I did not.
One morning, before dawn

I sneaked into the Brother's room
And softly took his cane from off its hook,
And brought it swiftly down on him as he slept.
He howled at the rude awakening.
'You, you are the worst of all,'
He said as I showered him with blows,
'You should thank God and us upon your knees
For saving you from the murderous sea,
That's how much the filth, the scum,
From which you come, cared for you.
You'll pay for this!'
But I now had his keys
And with one last blow across his face,
I dropped the cane upon the bed
And, without a shoe upon my foot, I fled that place.
Some hours later,
At the crossroads above Threemiletown,
I met a group of men who barred my way.
It was them or me.
I killed their leader,
Who matches your description of your father.
The rest ran away.

 Beat.

Nothing would ever get in my way again.

YOUNG MAN
An hour later, Jackson is back down –

MAN
'But,' she says, 'his men said it was a gang of thieves.
One man cannot be many.'

OLD MAN
No, I said to her, one man cannot be many,
But many are the faces one man might have.

YOUNG MAN
An hour later Jackson is back down,
Sobered. Embarrassed.
'Where's Seán?'
'Mr Jackson, the others had to go.

Did they? … Did he…?' He looks around the bar.
The tart is back upon her stool
Waiting for her next one.
He wises to the dodge.
'No, they don't know,' I say.
'I should be going too,' he says.
'I'll walk with you,' I say.
'No, it's okay.'
'I'll walk with you all the same.'
He looks at me.

MAN
Tell your brother Seán, I tell her, bring the old fella here.
I'll know the truth of it one way or other.
A rumour left to fester becomes a plague.

YOUNG MAN
'Those contracts,' I say to Jackson as we walk,
'That are out to tender, when do you decide?'
'Few days.'
'Well, I am sure that I can quote you lower
Than all your John Bull companies.'
He stops and looks at me.
He despises me, I can see.
'I'll not be digging all my life,' I say
'I'm doing this for my son,
I'm doing this for my wife.'
'Your wife,' he says, 'does she know what you do at night?'
'No, but unlike you, I'm not afraid to tell her.'
'Digging dirt is all you're good for,
You Paddies from the bog.'
'Don't worry, Mr Jackson,
In time you'll come to like me,
Appreciate me at the least.
And in time all us Paddies
Will seem no different to you.
In fact, have I not become a bit like you already?
But my son, he'll be better than us both.'

8.

MAN
She's coming from her brother
When I meet her on the stairs.
She looks different,
Haunted, drawn.
So?

OLD MAN
I've talked to him, she said,
He'll have this man you ask for,
The Angel Sweeney,
Brought to the yard immediately.
But you'll excuse me if I don't stay, she said.

MAN
Why, my love?
No secrets from each other, remember?

OLD MAN
Because, she said, because I refuse to look upon
The killer of my son.

Beat.

MAN
She turns to go back to her room.
No, don't walk away from me. I follow her.
You had a child? Another child, before?
And you're connected to this man?
So it is no accident that he's come.

OLD MAN
All, all is accident, she said, cruelest accident.

MAN
I need to know, I say, tell me.

OLD MAN
I told you, she said, my father sent both Seán and me away.
And you asked why us both?

MAN
And you said it did not matter.

OLD MAN
He sent me away because he feared me, she said,
More than he feared my brother.

MAN
The Boss Carbery feared a young girl?

OLD MAN
Or maybe it was just himself he feared, she said.

Beat.

MAN
He desired you? I say.

OLD MAN
Let that be enough, she said.

MAN
No, I need to know. He wanted you?
Is that what he feared?

OLD MAN
He wanted me, and he had me.
Is that enough for you?
And I had a child.

Beat.

OLD MAN
You wanted to know, she said.
And now you do.

MAN
A child? I say.

Beat.

MAN
And this child…?

OLD MAN
That child is dead, she said.

MAN
How do you know?

OLD MAN
This man, the Angel Sweeney, she said,
He did my father's dirty work for him.

YOUNG MAN
Later, I crawl into our cold bed, bone weary.
She is awake but doesn't speak.
I kiss her heavy belly.
My son, my child.
What I've done, I have done for you.

OLD MAN
But I will go to my room, she said, I cannot face him.

YOUNG MAN
Some hours later I wake in bed alone,
The sheets are wet.
From the shared bathroom on the landing
I hear her moan.
She lies on the floor behind the door.
'It's coming. Help me. I cannot move.'
'What? What do I do?'
'Ease the head out,
Slowly turn him round.'
'Have you done this before?' I joke.
She cries in pain.

Uncertainly the YOUNG MAN gets to his knees.

YOUNG MAN
'Easy, breathe.'
While I, his head ease out, inch by bloody inch.
'It's okay, he's okay my love, his head's appeared.
Do not give up, do not despair.'
Now his shoulders, I can see them.
She howls as if this child broke her in two,
Then in a bloody rush the rest of him arrives.
A thing of wonder, a glorious sight,
A son!

9.

MAN
'He's here,' the Elephant comes to me and says,
'The Angel, the old fella from the Kingdom
He's waiting in the yard below.'
'Send him up so,' I say.
'He says he'll speak with you down there.
He says he fears your temper.'
'So, I'll go to him,' I say,
'Expose his lies for all to see.
I'm not afraid of any man.'

OLD MAN
(To himself.) I'm weary.
Show me a man who longs to live
A day beyond his time,
And I'll show you a fool.

MAN
This Angel, in truth a bird of a man,
Stands sucking on a smoke by the wall.
So you're the one who spreads these lies about me?

OLD MAN
I tell no lies.

MAN
Well that, my friend, is a lie itself
For all you say cannot be true.

OLD MAN
I know what I know, that's all I'll say to you.

MAN
Well let's see what you know then, I say.
Hold him, I say to my men,
So he does not run off like a coward once again.

OLD MAN
(To himself.) Not to have been born is best.
But if one is cursed to see the light,
The next best thing's to return to the dirt.

MAN

You were a pal of this Boss Carbery,
In the old days, in the Kingdom?

OLD MAN

Pal's perhaps too nice a word, he said.

MAN

You were with him, that day though, his last?

OLD MAN

(To himself.) Youth slips by like a bird unnoticed,
Unnoticed til it's no longer there.

MAN

At that crossroad beyond Threemiletown?

OLD MAN

(To himself.) At a crossroads beyond Threemiletown,
In the summer sun,
The seeds of my doom were sown.
(To MAN.) You seem to know the story better
Than I know it myself, fella.

MAN

How many were you? I say to him,
It must have been a large and vicious crew
To have slain your boss,
And set to flight the rest of you.

OLD MAN

(To himself.) Is it all just cruel accident, as she once said,
Are we condemned to grope blindly in the dark?
Is there no understanding in the end?

MAN

How many did you say that there were?

OLD MAN

At the time we said that there were five or six.

MAN

And was I a member of such a gang?

OLD MAN does not respond.

MAN

But now, years later, you come over here,
Down on your luck, glad to take my shilling,
Yet you are willing to risk all that,
By spreading it about that I was one of them.

OLD MAN

You were not one of them, no.

MAN

So you admit it, you have lied?
My men laugh at him.

OLD MAN

Only in the story that was first told.

MAN

How so?

OLD MAN

We were afraid what would be thought of us.

MAN

And you aren't afraid now?
He looks at me, around at my men.

OLD MAN

I no longer fear what men think of me, no.
You murdered him on your own.

Beat.

And on your own you set the rest of us to flight.

YOUNG MAN looks from OLD MAN to MAN.

MAN

My men look at me.
Well tell me this, my friend,
How can we trust the word of an admitted liar?

OLD MAN

I know what I know, he said, and I know that it was you.

MAN goes for the OLD MAN.

OLD MAN

I'd know you if you gave me a hundred blows.
And I'll tell you something only I could know.
That you tossed a coin to decide
Whether you'd let me live or die.

MAN

My men look now at me.
Most know the tale of how I won the company.
But I'll not be brought down by this man,
This coward to whom I once showed mercy.
Not only have I proved this man a liar, I say,
I also know him to be the killer of a child.

The OLD MAN does not respond.

You heard, I say,
It's you who is the murderer,
The murderer of a child.

OLD MAN

I never killed no child, the Angel said,
As God sees me.

MAN

Well I have it on higher authority, I say.

OLD MAN

Who? Who says that I did? he said.

MAN

I point to my wife
Watching from the window of her room above.
She did, I say.
Too late I see it is a look of horror on her face.

OLD MAN

(To himself.) We must know everything in the end.
Blind we live but all shall be revealed.
(To MAN.) I see, the Angel said.

MAN

What is it liar, murderer, you see?

OLD MAN

I see how you could think such a thing of me.

MAN

What do you mean?
What are you saying about my wife?

OLD MAN

I know what I know.

MAN

Better tell us so, and tell us fast.

OLD MAN

I know that sixteen years before he met his end
Your wife's father called me and another to his house.
His daughter lay upon her bed,
Bloody, spent, a baby at her little breast.
Boss Carbery took it from her.
"Take this," he said to me, "this unnatural thing,"
And thrust it in my arms, "take it to the shore,
Knock its brains out on the rocks,
And throw the carcass out to sea."
I looked at the little thing,
"But Boss…" I said,
But he'd already turned to the other fella.
"And you," he said to him,
"You take this bitch's whore away from here.
England, or further if you can.
Where she'll not tempt me with her tinker ways again.
I'll be free of the curse."

MAN

So you, you did what he told you?

OLD MAN

No, something stayed me to the spot, the Angel said,
Appalled to do what he asked of me,
Yet terrified what would transpire if I did not.
"What?" Boss said, "are you not gone yet?
Out of my road all of you, or you're dead."
I took the thing and left as he had bade me,
And went down to the sea at Finian's Bay.

But I couldn't kill it on the rocks like he said.
But laid it down upon the beach,
Hoping that the tide would reach
Out and wash all trace of it away.
But the little thing, the child,
Looked up at me and cried.
And I saw myself through his clear eyes;
A weak man, in thrall to an evil man.
"But you are not a bad man, no," he seemed to say,
"You will not go and leave me here."
And I thought myself blinded by his eyes,
My own tears scalded my face.
Something passed from him to me, a strength.
No, I could do many things,
But I could not take the life
Of a helpless creature such as that.
Perhaps that act will earn me a little credit
In the final estimation.

MAN

And though I fear what is to come,
Having started on this road,
I must continue on.
What, I ask the Angel,
What did you do with that child?

OLD MAN

I picked him up from where he lay,
And took him to the Brothers at *Ros na Gréine.*

MAN

The industrial school?

OLD MAN

Perhaps, the Angel said, perhaps they could give him
The life his father had denied him.

MAN

I look at the Angel, but am no longer seeing him.
Blind all my life I now see
For the first time both who and what I am.
So let that be the last thing I see.

YOUNG MAN
What? What is it? Are you that child?

MAN
But I do not hear my men's questions.

YOUNG MAN
So you killed your father, your own father?
And your wife is…

MAN
I am off and running,
Running to the store sheds
And pulling down from the stacks
A sack of lime,
And hacking it open with a spade,
And –

The MAN blinds himself with the dust.

MAN
So I might never see this world again,
I scald the eyes out of my head.

10.

YOUNG MAN
A few days after I wake in the chilly flat.
I feel not the cold, but the soft breath
Of my wife and baby son upon my back.
And through the dirty curtains streams
The watery winter London light.
And I feel joy.

OLD MAN
And in my darkness and my pain,
My life appears to me a dream –

YOUNG MAN
Joy at being alive –

OLD MAN
No sooner does it dawn –

YOUNG MAN
Being free, free from my past.

OLD MAN
Than it melts into the morning air.

YOUNG MAN
And I slip from the bed, let them sleep.
Take a scrap of paper from my pocket,
Go to the payphone in the hall.
'Jackson.'
'Yes.'
'The contract. Is it decided yet?'
'This morning at the meeting. It's yours,' he says.
'A man of honour and of principle,' says I,
'You won't regret it. How did John Bull take it?'
'Hard. I heard he gave your friend the Elephant his cards.'
'No matter, Elephant now works for me.'
'And he wants to see you at his yard at noon.'

A rumble of distant machinery.

YOUNG MAN
'Shall I tell him you'll be there?' Jackson says.

MAN
And all that happens after is as though a dream.
Her screams when she hears.

OLD MAN
What have you done to your eyes? Why?

MAN
When I tell you, you will wish
That either you or I had died.

OLD MAN
Tell me, she said, I must know.

MAN
And after I tell her, she goes to her room,
And when I follow, I find that it is locked.
I have my men force the door.

A distant explosion.

MAN
What is it? Tell me what you see.

OLD MAN
In my mind's eye I see her swinging back and forth
From a noose made from our bedsheets.

MAN
Let me go to her, hold her in one last embrace.
Help me men. Help me take her down.

YOUNG MAN
Me and Horse arrive at John Bull's yard at noon.
Twenty men or more stand yarning, smoking, loafing.
They see us and grow silent.
'I'm looking for the gaffer.'
'He's expecting you.'
'I'll wait for him so.'

MAN
All the blind night I sit with her
Her hand, earth cold, in my own.
Near dawn Elephant comes with my son.

Where are you, son? Let me touch your face.

OLD MAN

'Uncle Seán has told me everything,' he said.
'Away from me, murderer, leave me be.'
'We've talked and we've agreed,' said Elephant,
'I'll take charge of the company
Until he reaches his majority.'

MAN

This is my company, I built it brick by brick.

OLD MAN

'You built it by good luck, and your luck's changed.
And fair is fair, we are now brothers after all.

MAN

And me? What shall I do?

OLD MAN

'You will leave this place,' he said,
'Your presence pollutes our reputation.'

MAN

And son, is this what you want?

Pause.

OLD MAN

'Out of my way, Old Man,' he said.

MAN

My son, everything I've done, I've done for you.

OLD MAN

'Out of my road,' my son said, 'shit on my shoe.'

YOUNG MAN

You'll not find me digging all my life,
I'll not be blinded by the dust or lime,
You'll not find me bent and broken by the damp.
I've got plans, I'm my own man.

YOUNG MAN looks at OLD MAN.

YOUNG MAN

At ten past the man himself comes down.
Slow and heavy he crosses the yard,
Smoking all the while a fat cigar.

MAN

Please, my son.

OLD MAN

My son did not reply, and I,
I was cast out.
Back onto the road I first walked down.
Alone.

YOUNG MAN

'So you're this Mick,' old John Bull says,
His voice thick as Yorkshire pudding,
'Who stole the contract from under my nose?
And my ganger says not three weeks ago
You worked here as a casual for me?
A meteoric rise, would you not say so, Mick?'
'Free country, at least it's supposed to be,' I say.
'Too free, if you ask me,
Some people don't know their places anymore.'
'And what would my place be then so?'
He bites the soggy end off his cigar and spat it out.
'You played it well, Paddy, I'll give you that,
But it was no more than beginner's luck.
So here's what I'll do, I'll make a deal with you.
I'll give you fifty pound,
Only because I like your spirit, mind,
And then you can fuck right back off down
Whatever hole or ditch from which you climbed.'
'And if I don't accept your deal?'
'It's a dangerous game, Paddy,' John Bull says, 'people get hurt.
You need muscle in this trade.'
That was the signal, the men move closer in.
I look around at them,
Their battered boots and breeches, worn out braces,
I look into their hungry, cowed faces;
These are not the pride of Hackney, Harringey or Hull,

But the lost sons of Kerry, Cork and Donegal.

YOUNG MAN looks to the MAN and OLD MAN.

YOUNG MAN
'I've got men enough,' I say.
'What? You and your friend?'
He laughs. The men follow suit.
'Where's your army?' he says.
'Here.'
'What are they then, fairy folk?'
They laugh again, less sure.
'No,' I say, 'these men, who when they hear
That if they come and work for me,
That I'll pay them what you pay them and half again,
And not cheat them of their wet days,
Nor lay them off while still claiming for their wage,
They will be my men not yours.
Who'd you rather sweat your lifeblood for,'
I ask them, 'a fat old bull who cares more
For lining lawyers', policemens', politicians' pockets
Than the welfare of his men?
Or one who knows how hard time goes
When it's cold, and your hands are blistered,
And you're digging a hole that never ends?
Who do you choose?'
John Bull looks around his men.
'You bastards know which side your bread's buttered on.
Beat him, throw him back out on the street.'
But not one moves against me.
'Do what I say,' he says.
'I'll beat no brother from the Kingdom, sir,
Not for any English man,' and turning to me he says,
'And if what you say about a job is true,
I'm with you, fella.'
'And me! and me!' they say.
'Go then you worthless Paddies,' says John Bull,
'There's others that can do your jobs.'
'No there's not,' I say, 'that's why we're here.
You need us.
But since I'm feeling lucky, I'll give you a chance,

A deal as you might call it.'
I take the dead man's coin from my pocket
And I say –

OLD MAN
'Heads, you get the council contract,
Your fifty quid, and I walk away.
Harps, I get the lot, all contracts, the men, the yard.'

YOUNG MAN looks to OLD MAN.

OLD MAN
And John Bull says, 'You're fucking mad, you are Mick.'

YOUNG MAN
'Fair deal, you have a fifty-fifty chance.'

MAN
But trapped in a circle of his own men, he has no choice.

YOUNG MAN looks to the MAN now.

MAN
'Fuck it then Mick, I feel lucky too and all –

OLD MAN
'Toss your coin in the air, then let it fall – '

YOUNG MAN makes the gesture of throwing the coin, he looks up. For a brief moment the triumph and the memory of the triumph are present for all three.

11.

YOUNG MAN
Is this how it ends so?

OLD MAN
No. First you will turn towards Holyhead, for home.
But as you near you'll question
What of home remains for you there?
Then after you will just tramp the road,
Tramp for what will seem like years.
Until one day, beyond Daventry,
You will scramble up a grass embankment,
On all fours, like a wounded animal,
And find yourself in what was once a clearing.
The air it will smell sweet, the birds will sing.
'You, I'm sorry but you can't stay here,'
A voice, an old woman, will call to you.
'Excuse me,' you will say, 'excuse me
But what class of a place have I come to?'
'A shrine,' she will reply, catching her breath.
'They say that miracles took place here once,
But it's fallen into disrepair, all overgrown,
The grotto's but a pile of stone,
And the nuns who tended it, grown old and died.
I am the last of them.
We sold it to the motorways,' she'll tell you,
Half-embarrassed, half-sad,
'They're widening the road.
They began blasting earlier today.'
'And the shrine,' you will ask her, 'is it a shrine to Our Lady?'
'Our Lady of Succour,' she will say.
'And your convent's up beyond?' You will ask, to be sure.
'You've been here before?' she will say.
'Do you remember a young woman,' you'll ask her,
'Forty years ago or more, from across the water?
In trouble with her father,
You gave her shelter.'
'I recall several such,' the nun will say,
'They were simpler, but harsher times.'
'But this girl you would remember,' you will say,

'The blackest hair, the palest skin, and eyes so blue.'

Pause. All three men wait for a response.

OLD MAN
'I remember one such as you describe,
But all the many faces blur into one.
And her name, her name has, I'm afraid, gone.'
A blast will come, closer than the last.
Now you really must be going, the old nun will say to you.
'No,' you'll say, 'I will not leave this place.
There will be understanding in the end.'
'You can't,' she will say, 'the blasting.'
'Listen,' you will say.
'What?'
'Do you not hear?' you'll say, 'A voice from home,
Like a half-remembered song,
Our Lady of the Road.
Lead me to the statue,' you'll demand.
'But it is just a mound, it's been desanctified.'
'It is not for men to determine
When sanctity departs,' you'll say,
'Lead me there. This shall be my resting place.
I've built the roads and tunnels,
Tracks and bridges of this foreign land,
The arteries, I'll be buried in its blood.'
And against her better judgement, she will relent
And hand in her hand, through the ruins of the shrine,
She'll lead you to where the mound of rocks
That was once the shrine stands.
And you'll hear the distant thuds of the blasting.
And she'll bless you and leave hurriedly.
And you'll climb on up the mound alone.
Must keep going, you'll say to yourself,
Through the other side soon,
Then the open road, the sun…

Pause. To black.

www.ingramcontent.com/pod-product-compliance
Ingram Content Group UK Ltd.
Pitfield, Milton Keynes, MK11 3LW, UK
UKHW031252020325
455690UK00007B/70

9 781849 434874